LOVE'S
MESSENGER

TOKENS
OF AFFECTION
in the
VICTORIAN
AGE

CHRONICLE
BOOKS
GIFTWORKS

ISBN: *0-8118-1743-1*

*This book was published in
cooperation with The
Art Institute of Chicago.*

Written by Debra N. Mancoff

*Photographs of valentines
by the Department of
Imaging, The Art Institute
of Chicago*

*Edited by Sarah H. Kennedy,
assisted by Kate Irvin*

*Distributed in Canada by
Raincoast Books
8680 Cambie Street
Vancouver, B.C. V6P 6M9*

10 9 8 7 6 5 4 3 2 1

CHRONICLE BOOKS
*85 Second Street
San Francisco, CA 94105
www.chronbooks.com*

Design by studio blue

*Art direction
by Miranda Design*

Manufactured in China

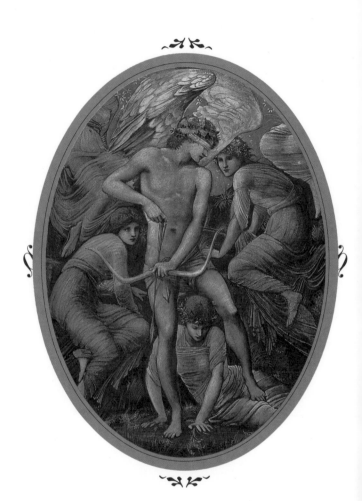

LOVE'S
MESSENGER

TOKENS OF AFFECTION IN THE
VICTORIAN AGE

A CARELESSLY SENT VALENTINE sets the plot of Thomas Hardy's 1874 novel *Far from the Madding Crowd* in motion. Bathsheba Everdeen, the independent-minded heroine of the tale, buys the card on impulse. The valentine's bright colors, elegant embossing, and oval enclosure for a personal message had caught her eye.

Bathsheba decides to give the valentine to the young son of one of her field workers, but her maid urges her to send it instead to Farmer Boldwood, a confirmed bachelor who has been staring at her in church. Bathsheba takes the dare, writes a verse in the oval, and puts the unsigned card in the post. Boldwood recognizes Bathsheba's handwriting and takes the valentine as a declaration of her love. She refuses his proposal of marriage, but Boldwood persists in demanding her hand. Her loveless marriage to another gentleman eventually drives Boldwood to insanity and murder. All this turmoil over a valentine!

Modern experiences with hearts and flowers can hardly compare. For children today, Valentine's Day offers a break in the classroom routine. They exchange cards – decorated with their favorite cartoon characters and sports heroes – with friends at a party in school. For adults, the card is now often overshadowed by a gift of candy, flowers, jewelry, or even a romantic dinner for two.

But in Hardy's day, a time of regulated courtship and restrained emotions, the valentine had genuine power. Don't be deceived by the whimsical appearance of Victorian valentines: these confections of paper lace, scraps of silk, and artificial flowers were serious symbols of honorable intentions. The act of choosing and sending a valentine allowed men, and especially women, to share the feelings they hesitated to express in words. No wonder the casual gesture of Hardy's heroine had disastrous consequences. According to the rules of Victorian romance, a valentine was "love's messenger," the most sincere communication from heart to heart.

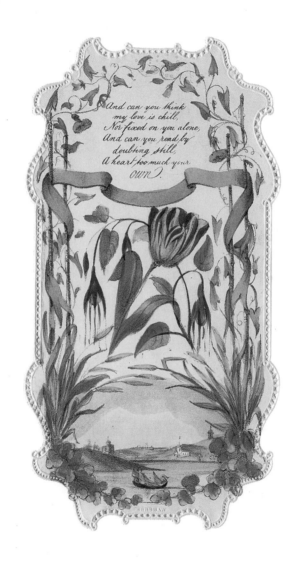

And can you think
my love is chill,
Nor fixed on you alone,
And can you rend, by
doubting still,
A heart too much your
OWN.

LOVE ME, Sweet, with all thou art,
 Feeling, thinking, seeing;
Love me in the lightest part,
 Love me in full being.

ELIZABETH BARRETT BROWNING
from "A Man's Requirement"

I LONG this lovely maid to wed,
> And when I call her mine,
How happily my life will pass
> With such a Valentine.

from *"The Girdle of Venus*
or True Lover's Delight,
an Original Valentine Writer,"
19TH CEN.

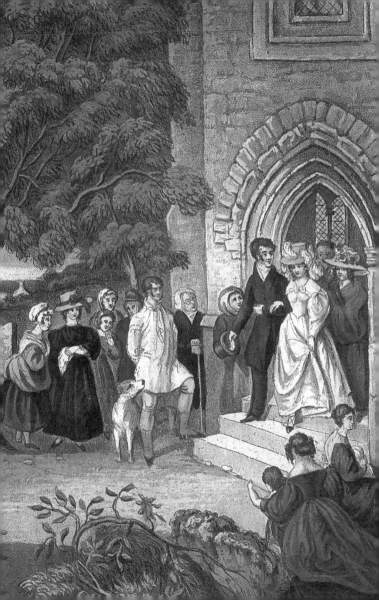

HASTE FROM MY LATTICE letter fly
Tell the youth for him I sigh.
Zephyrs bring me back the tender kiss
Of constancy – of hope – of bliss.

VALENTINE, 19TH CEN.

BLUEBELLS SYMBOLIZE CONSTANCY.

THE SAINT

of

SENTIMENT

VALENTINE'S LEGACY

THE ORIGINS OF OUR CONTEMPORARY celebration of romance have little to do with hearts and flowers. According to *The Golden Legend*, written by archbishop Jacobus de Voragine around 1260, Valentine's name Valens Tino identified him as a valiant soldier for Christ. A Christian priest in pagan Rome, Valentine was imprisoned and beheaded in A.D. 273. Nothing in his history connects him with lovers, but his death fell on the day tradition marked as the time for birds to choose their mates.

Valentine's martyrdom also occurred on the eve of Lupercalia, an ancient fertility rite conducted by an old order of the Roman priesthood. The celebration began with the sacrifice of dogs and goats. The blood of these animals was mixed and used to anoint the heads of two small boys, who then ran naked through the streets armed with goatskin thongs, striking at every woman who crossed their path. Believed to ensure fertility for the coming year, these gentle blows were happily received by women, who even placed themselves within the boys' reach.

During the Middle Ages, some pagan and Christian traditions converged, and, by the fourteenth century, Valentine became the patron saint of lovers. Apocryphal stories enhanced his legend. While in prison, he was said to have blessed Christian marriages and to have remembered the kindness of his jailer's daughter,

who had brought him food and water, in a death note signed "Your Valentine." In "The Parlement of Foules" (c. 1375), Geoffrey Chaucer celebrated Valentine's feast day as a holiday for lovers. He wrote that birds joined on Saint Valentine's Day remained partners for life, and he urged everyone to follow their example.

As the Middle Ages waned, Cupid's forces joined with the saint and the birds in popular lore. John Lydgate encouraged men to seize the time and choose their mates: "Seynte Valentine of custome yeare by yeare/Has given men a custome in this region/To loke and serche Cupid's kalendare/And chose theyre choice, by grete affection" (1440).

Other traditions suggested that love was not a matter of choice. It was widely thought that the first unmarried woman a man saw on Valentine's Day morning was his destined wife. Ophelia reminds Hamlet of this belief when she sings, "Tomorrow is St. Valentine's Day/All in the morning betime./And I a maid at your window/To be your Valentine." Many women left nothing to chance and hid at dawn behind doors and beneath windows so they could be seen at the proper moment. The drawing of lots for sweethearts also emerged at this time, as adults appropriated a child's game for the holiday ritual. These popular customs gave rise to the notion that love is blind, and that anyone at any time can be the target of Cupid's arrow.

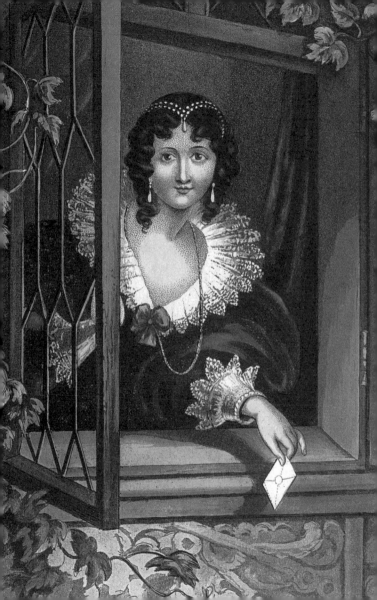

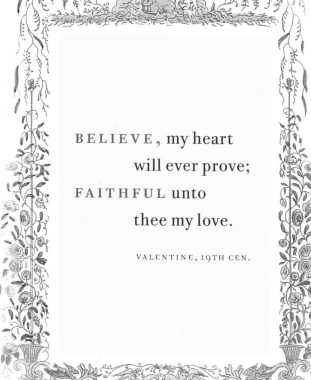

BELIEVE, my heart
 will ever prove;
FAITHFUL unto
 thee my love.

VALENTINE, 19TH CEN.

m y

fLUTTERING HEART
DOTH·fEEL LOVE'S SMART.

"Cupid in Ambush"

VALENTINE, 19TH CEN.

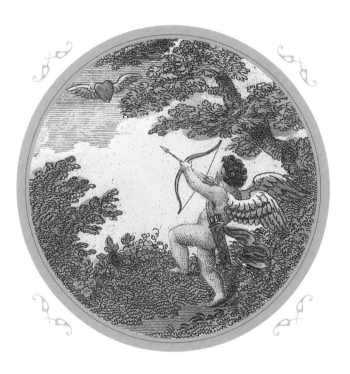

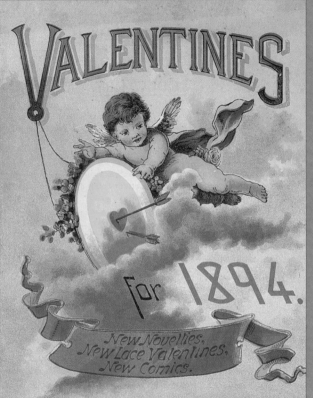

VALENTINES

for 1894.

New Novelties,
New Lace Valentines,
New Comics.

McLoughlin Bro's
874 Broadway,
NEW-YORK

HASTE AND BOW at Cupid's shrine
And welcome in St. Valentine.
All be merry, frank, and free
And form the Lover's Jubilee.

from a *"Valentine Writer,"*
19TH CEN.

HEARTFELT

and

HANDMADE

THE ORIGIN OF LOVE TOKENS

AND RITUALS

ACCORDING TO LEGEND, the Duc d'Orleans began the English tradition of writing love letters on Saint Valentine's Day. The noble French warrior was captured by English forces in 1415 at Agincourt, the last great battle of the Hundred Years' War. Incarcerated in the Tower of London, he passed his time writing romantic poetry, and on the fourteenth of February sent his fiancée the following verse: "Wilt thou be mine? dear love reply – / Sweetly consent, or else deny; / Whisper softly, none shall know – / Wilt thou be mine, love ay? or no?"

The exchange of gifts on Valentine's Day became popular in the seventeenth century. Reviving the medieval practice of drawing lots for partners, groups of friends, members of families, and residents on large estates selected valentines by chance. The most common gifts included garters, gloves, and stockings. Though exchanged with friends, not sweethearts, such innocent gifts, worn on the body like a second skin, could be highly provocative, as the following anonymous verse reveals: "Blush not, my fair, at what I send / 'Tis a fond present from a friend / These garters, made from silken

twine / Were fancied by your Valentine / The motto, dictated by love, / Is simply – Think on what's above."

By the mid-eighteenth century, Valentine's Day exchanges were more modest and personal. Love tokens – handmade with someone special in mind – replaced suggestive and extravagant gifts. The love knot, a twist of ribbon and hair, was the most popular. It inspired love-knot drawings, with endless poems written within the complex design. Gloves endured as a favored symbol, now made out of cut paper. Another paper token was the puzzle purse; through clever folding, a single sheet opened in stages, slowly revealing a tender message.

Romantic letters, recalling the model of the Duc d'Orleans, returned to fashion. But the British postal system stood in the way of heartfelt intentions. The recipient, rather than the sender, paid the postage. Rates were charged by distance, and to enclose a message in an envelope for privacy doubled the fee. Nonetheless, the custom grew, and new, elegant papers were produced in Europe, encouraging sentimental exchange.

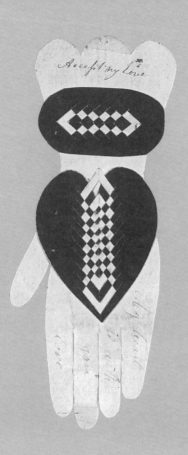

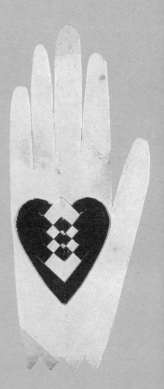

"Cut-Paper Glove" VALENTINE,
19TH CEN.

accept this

OFFERING DEAREST TRUE

faithful

BIDS ME PAY TO YOU!

VALENTINE, 19TH CEN.

BLUE FORGET-ME-NOTS
SYMBOLIZE A DELICATE, LOVING NATURE.

ALL HER FACE

 was honey to my mouth
And all her body
 pasture to mine eyes;
The long lithe arms
 and hotter hands than fire,
The quivering flanks,
 hair smelling of the south,
The bright light feet,
 the splendid supple thighs
And glittering eyelids
 of my soul's desire.

ALGERNON CHARLES SWINBURNE,
from *"Love and Sleep"*

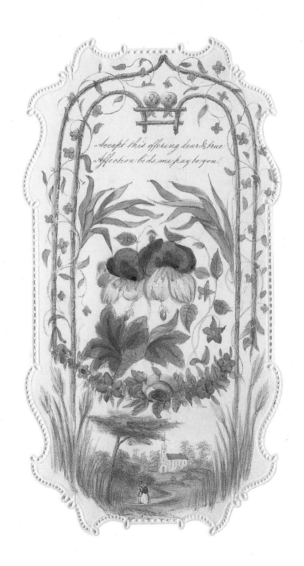

FORGET ME NOT. Forget me not.

 But let these little simple flowers

Remind thee of his lonely lot

 Who loved thee in life's purest hours.

VALENTINE, 19TH CEN.

HONORABLE

INTENTIONS

VALENTINES AND NEW RULES
FOR LOVE

IN 1797, BRITISH PRINTERS PRODUCED the first ready-made valentine cards. These missives combined images of popular love tokens with simple, inscribed verses. Fancy papers gave an air of luxury. Embossed sheets with rich relief designs and paper lace with delicate cut-out patterns were also available for handwritten and personalized letters. "Valentine Readers," inexpensive pamphlets with sample verses, offered poetry for romantic correspondence. The stock verse was mostly doggerel of the "roses are red" variety, but specialized booklets also appeared with poems for different relations, various ages, and even professions.

Despite these elegant innovations, British valentines remained modest in the early nineteenth century due to the high cost of postage. To avoid excessive charges, most valentines comprised a single sheet of paper, folded in thirds for privacy. Cheaply printed comic valentines, with insulting verses that ridiculed the recipient's appearance or intelligence, also came into circulation. Sent anonymously, these comic valentines led to complaints to the postmaster general. Irate fathers who paid for rude messages sent to their daughters demanded that their postage be refunded, and, by 1817, the practice of sending such valentines was officially discouraged.

By the 1830s, a new moral attitude changed British views of love and courtship. This was due, in part, to a new generation's reaction to the excessive habits – drinking, eating, gambling, and womanizing – of the playboy monarch George IV, who reigned from 1820 to 1830. It also reflected the more domestic views of a new middle class, who saw their stability rooted in home and family. Etiquette books offered advice to couples about courting, gift giving, and the importance of a chaperon. Books like *The Etiquette of Courtship and Marriage* (1844) and *The Etiquette of Love* (1849) reminded women to keep their feelings secret, since it was the male prerogative to advance the courtship; the only female right was to refuse. All proper courtship held a single end and that was marriage, regarded as the true source of feminine fulfillment.

A new type of ready-made valentine reflected these changing attitudes toward romance. Narrative scenes, with lithographed outlines and hand-colored details, portrayed happy couples strolling in blooming bowers, listening to love birds, and following the garden path to the wedding chapel at the local church. Handsome soldiers and sailors longed for sweethearts left behind, while those waiting women demonstrated their patience as proof of their virtue. These modest

cards were cheaply and widely printed, and their single-fold sheet allowed the sender to write a personal – and private – message. The valentine offered the one exception to the rule of feminine discretion; a woman could not declare her love verbally, but she could send a valentine.

Queen Victoria and Prince Albert set the model for Victorian courtship and marriage. Shortly after her accession in 1837, Victoria became engaged to the handsome German prince. Their fairy-tale wedding on February 10, 1840, delighted the nation, and the illustrated journals portrayed them as ideal sweethearts. The queen made it known that she honored her roles of wife and mother as much as her duty as monarch. She and Albert came to represent the rewards of domestic romance. A set of souvenir valentines featuring their royal castles molded in cork commemorated their first anniversary, and, in the following years, the queen's portrait was embossed on select holiday cards.

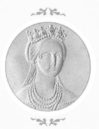

*Queen Victoria featured
on a valentine.*

A WISH.

May God's mercy preserve thee,
His power protect thee,
His goodness provide for thee,
His wisdom direct thee.
May thy life be a happy one;
May sorrow and care
Never sadden thy heart,
Nor find a place there.

Earth's Heaven.

TWO souls that are sufficient to each
other—sentiments, affections, passions,
thoughts, all blending in love's harmony—
are earth's most perfect medium of heav-
en. Thro' them the angels come and go
continually on missions of love to all the
lower forms of creation. It is the halo of
these heavenly visitors that veils the earth
in such a golden glory, and makes every
flower smile its blessings upon lovers.

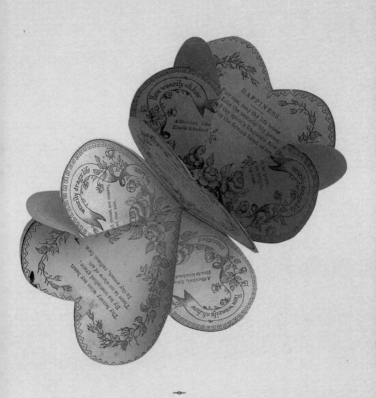

OPEN VIEW

LOVE FOR THE MAIDEN crown'd with marriage,
 no regrets for aught that has been,
Household happiness, gracious children,
 debtless competence, golden mean.

ALFRED, LORD TENNYSON, from *"Vastness"*

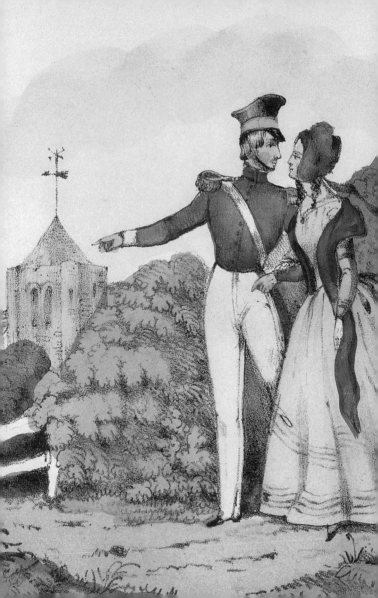

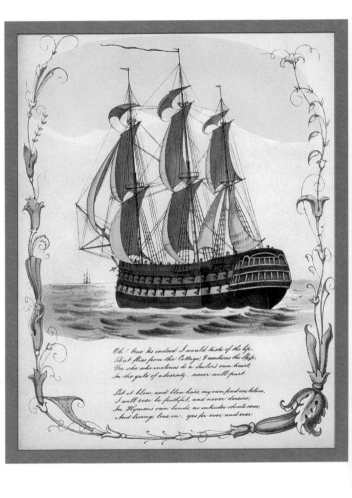

Oh! true 'tis indeed I would taste of the life,
That flies from the Cottage, & ventures the Ship,
For she who inclines to a Sailor's own heart,
In the gale of adversity – never will part.

Let it blow, and blow hard, my own fond one below,
I will ever be faithful, and never deceive,
In Hymen's own bonds, no intruder should sever,
And living, love on – yes for ever and ever.

WILD NIGHTS – WILD NIGHTS!
 Were I with thee
Wild nights should be our luxury!

Futile – the Winds – To a Heart in port –
 Done with the Compass!
 Done with the Chart!

Rowing in Eden – Ah, the Sea!
 Might I but moor – Tonight – In Thee!

EMILY DICKINSON, *"Wild Nights"*

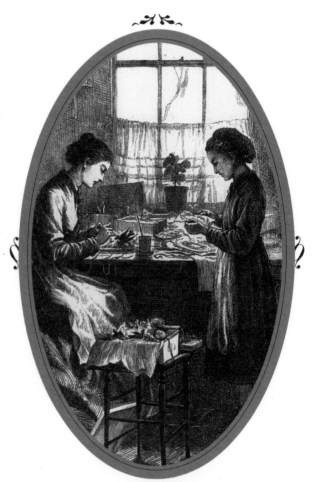

WITH FONDEST
AFFECTION

THE VICTORIAN
VALENTINE

READY-MADE VALENTINES became a booming business in Victorian England. By the middle of the nineteenth century, the finest London stationery shops, including Dobbs and Company, Joseph Mansell, and George Meek, produced their own specialized lines, using paper lace, ribbon, silk, and cut-paper flowers and leaves.

The introduction of the national penny post in 1840 established a single, prepaid rate throughout the country for a half-ounce letter. This both increased the cards' popularity and led to the design of elaborate envelopes, making the package as appealing as its contents. The fashion for cards pushed the postal service to its limit. In 1841, more than 400,000 valentines were delivered throughout England. By 1871, three times that many were sent in London alone.

The vogue for valentines soon crossed the Atlantic. American traditions were based on the English customs. Parties and games marked the American celebration, offering a bright diversion from midwinter doldrums. Emily Dickinson wrote to her brother of a delightful holiday in 1848: "I am sure I shall not very soon forget last Valentine week, nor any the sooner, the fun I had at that time." Despite high postal

rates – five cents for a range of three hundred miles – Americans also enjoyed exchanging cards. In New York, the number of valentines posted doubled from 15,000 in 1843 to 30,000 in 1847. A reporter for the *Philadelphia Public Ledger* claimed some postmen needed wheelbarrows to deliver their Valentine's Day loads, and he marveled at a delivery man "staggering under a huge market basket filled with the dainty epistles."

Few English valentine makers rivaled the success of the American entrepreneur Esther Howland. After graduating from Mount Holyoke College, Howland worked in her father's Wooster stationery shop. In 1848, upon seeing a set of imported valentines, Howland began making her own. Once these were displayed, the orders came pouring in. At first she called on her old college friends for help, but by 1849 she had set up a factory, employing five women who worked assembly-line fashion, each with an assigned task. Of all her designs, the most popular was the "Maybasket," an extravagant combination of raised paper, artificial flowers, and leaves. To make a grand impression on his fiancée, one of her clients ordered a ten-dollar Maybasket, but the

generous gift had the opposite effect. The woman promptly broke the engagement, believing that her fiancé's easy way with finances would lead them to a debt-laden future.

Creative combinations of materials gave Victorian valentines their distinctive richness. In 1845, English Valentine maker David Mossman added artificial flowers made of silk and satin to a paper card, making a three-dimensional collage. Paper lace borders surrounded medallions of embossed papers, silk, or netting. Esther Howland often inserted a bright piece of tissue to set off the pierced pattern of a lace cover. With the invention of oil-color printing, English manufacturers produced sheets of hearts, flowers, love birds, and cherubs. These were used by commercial card makers, but could be purchased in stationers' shops. Once these "scraps" were clipped, they could be used to seal envelopes or added to a purchased valentine for extra embellishment.

Every image on a valentine conveyed a message of love. Anchors and oak leaves proclaimed a sender's fidelity, while love birds and wedding rings illustrated honorable intentions. Flowers were a favorite symbol, and bouquets combined

the individual meanings of blossoms into elaborate messages.
The pansy with its message, "You occupy my thoughts,"
was an enduring Victorian favorite, since it conveyed interest
while maintaining decorum. Blue forget-me-nots spoke
of a delicate, yet loving, nature, while pink roses expressed the
desire for romance. Little bluebells stood for constancy,
bold tiger lilies for courage, and zinnias for thoughts of ab-
sent friends. Saint Valentine's long-standing emblem
was the crocus, and although the early spring bloom symbol-
ized resolve, it rarely appeared on Victorian valentines.

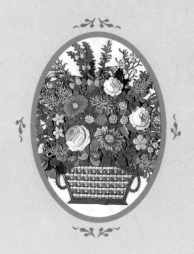

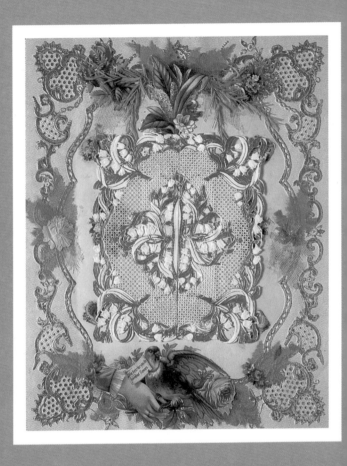

CLOSED VIEW

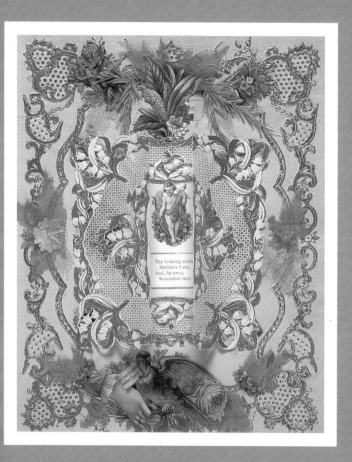

Thy beaming smile
Methinks I see,
And, far away,
Remember thee.

>>> OPEN VIEW <<<

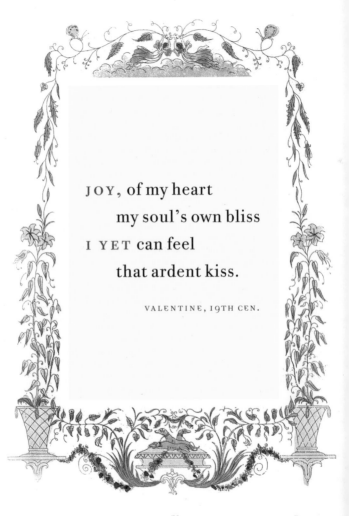

JOY, of my heart
　　my soul's own bliss
I YET can feel
　　that ardent kiss.

VALENTINE, 19TH CEN.

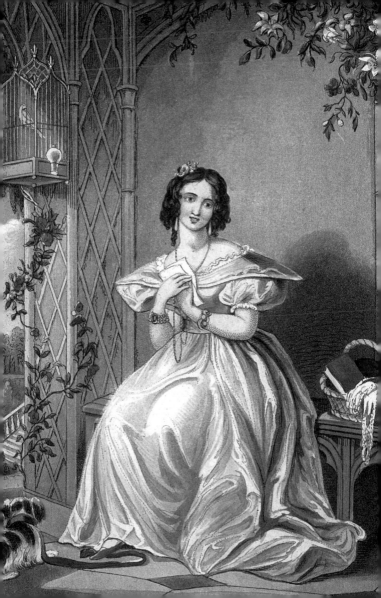

HOW DO I
LOVE THEE?

THE HERITAGE
OF VICTORIAN ROMANCE

DURING THE VICTORIAN ERA, romance resembled an elaborate game. Men and women approached each other with caution, shaping their emotions to society's standards. When a man expressed his affection, a woman hid her enthusiasm. To be eager would be unfeminine, or it might unduly arouse the suitor. In the name of modesty, expensive gifts were discouraged; in the name of discretion, courting couples referred to each other as Mr. and Miss. Any thoughtless act – an ungloved hand on a lady's shoulder, a gentle finger brushing a stray curl – could ruin a woman's reputation.

Etiquette manuals warned against public displays of affection and the open expression of desire. According to Alex M. Gow, author of *Good Morals and Good Manners* (1873), "No gentleman will attempt it; no lady will permit it." Better to conduct the romance through the exchange of letters and gifts, and, thus, slowly escalate the stakes in the courtship game. But even correspondence was subject to rules. Letters could be sent only with parental approval. Every word had to be carefully chosen, correct in spelling and grammar, and, of course, in tempered sentiment. To negotiate the complexities of correspondence, books like Hill's *Manual of Social and Business Forms* (1874) and Elizabeth Gaskell's *Compendium of*

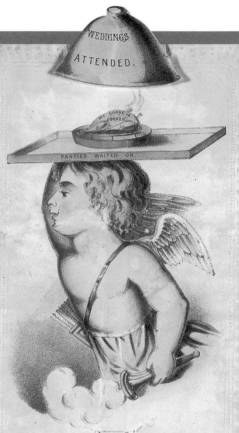

The poets sing of Love, as of a god divine,
I only wish the poets felt Love as strong as mine,
I only wish like me that their poor heart was hooked,
Then would they sing like me, alas:—

Forms (1882) provided model letters ranging from widowers'
proposals to the gracious breaking of an engagement.
Gaskell's *Compendium* assured the user that, "a loving heart nat-
urally imparts its glow to the written word." The book's
set of "Letters of Love and Courtship" opens with a bright – but
ironic – suggestion: "Let the heart speak free!"

Few dared to break the rules of romance, but there were many
ways to stretch them. The elaborate etiquette of calling
cards allowed for the exchange of discreet endearments. Many
were hand-painted, brilliant in color, and lavish in design,
with room for a personal message. On some, the caller remained
anonymous, his name hidden beneath a pretty scrap of
cut paper or silk. Others used a rebus to disguise a modest
proposal: "May I see you home my dear?"

Valentines introduced an element of play into the stern rules
of the game. Beehive cards, with cleverly cut spirals of
paper, bore secret messages. When the ribbon affixed to the
center was lifted, a surprise appeared. Mechanicals, with
paper hinges pulled by tabs, also offered a hidden dimension.
Some were bawdy; a little pull gave the viewer a tempting
glance at an ankle, petticoat, or more. Novelty valentines,

telegrams from "Loveland," and currency drawn from the "Bank of True Love," enjoyed a quick vogue, until warnings from the British Department of the Treasury ended their popularity. Comic valentines reappeared, but in a gentler mode. Many portrayed an old bachelor receiving amorous proposals, while giggling young women watched his distress. But unlike Hardy's heroine Bathsheba, who suffered for her prank, senders of these playful cards simply enjoyed a good laugh at someone else's expense. But just in case, most of the comic valentines were sent anonymously.

Three-dimensional valentines, built up on paper springs and layered with lace, net, and formed tissue, often required special boxes for shipping. Perfumed sachets, hidden in wreaths of dried and artificial flowers, extended the sensual pleasure. By the end of the century, a simple card was hardly enough to express fond feelings. Gifts of photographs, scent bottles, paperweights, and jewelry accompanied the holiday greetings. One odd novelty was the hummingbird box, with its perfectly preserved bird, surrounded by flowers and foliage, perched on a scented pillow. Since Roman times, the hummingbird symbolized male virility. Imagine the surprise

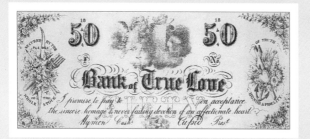

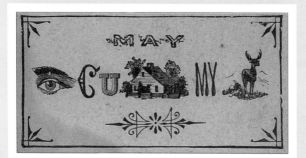

High Hose!
Or the
Inconvenience of an
Unmarried life

OB OB

Never too late to mend.

when the recipient opened the box. These ornate – and even bizarre – concoctions led one journalist to lament that the holiday had become tawdry, commercialized, and lacking in sentiment. He preferred the memories of his youth, for "a valentine was a valentine then."

Few men today – and even fewer women – would want to return to the strictly regulated rituals of Victorian romance. Free to choose, to act, and to respond according to the heart's wishes, modern lovers make their own rules. But nostalgia surrounds the Victorian legacy, and in a world of mass-produced and disposable cards, many long for the handmade and heartfelt keepsakes of the past. What pleasure to select the perfect card, its rich embellishment enhancing its modest message! How exciting to wait for the postman to see what surprises he brings! Essayist Charles Lamb recalled the thrill of opening his first valentine, "radiant, – all gold and gay colours . . . and glittering with devices, all of love." Looking back at the tokens of Victorian romance, even the most modern lover longs for the heightened sentiment, for as Lamb inquired: "A Valentine – who would not have a Valentine?"

PINK ROSES SYMBOLIZE A DESIRE FOR ROMANCE.

I HOLD IT TRUE what ere befall

I feel it when I sorrow most

'Tis better to have loved and lost

Than never to have loved at all.

ALFRED, LORD TENNYSON
from *"In Memoriam A. H. H."*

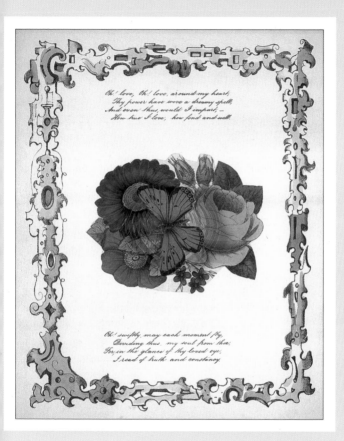

Oh! love, Oh! love, around my heart,
　Thy power have wove a dreamy spell,
And even thus, would I impart, —
　How true I love, how fond and well.

Oh! swiftly, may each moment fly,
　Dividing thus, my soul from thee;
For, in the glance of thy loved eye,
　I read of truth and constancy.

The following illustrations are from the collection of The Art Institute of Chicago:

Edward Coley Burne-Jones, detail of *Cupid's Hunting Fields* (1885); gouache on paper, 97.2 x 75.2 cm; R. A. Waller Memorial Collection, 1924.576 (p. 4).

Valentines, dating to the 19th century, donated by Mrs. E. B. Hodge: p. 8, 1919.383; p. 9, 1919.379; p. 10 (border), 1919.267; p. 11, 1919.309; p. 13, 1919.441; pp. 18–19 (detail and border), 919.306; p. 23 (detail), 1919.267; p. 31, 1919.310; p. 32, 1919.384; p. 33 (detail), 1919.330; p. 40 (detail), 1919.214; p. 41, 1919.251; p. 42, 1919.288; p. 43 (detail), 1919.250; p. 49 (detail), 1919.524; pp. 52–53 (border and detail), 1919.307; p. 62 (detail), 1919.431.

Valentines and love tokens, dating to the 19th century, donated by Paul E. Pearson: p. 28 (left), 1986.606; p. 28 (right), 1986.605; p. 37, 1986.506; p. 42, 1919.288; p. 56, 1986.520; p. 59 (top), 1986.483.

Other valentines and love tokens dating to the 19th century: pp. 20–21 (detail and detail), RX 20769/930; p. 22, RX 20769/948; pp. 38–39, RX 20769/933 ; pp. 50–51, RX 20769/965; p. 59 (bottom), RX 20769/859; p. 60, RX 20769/884; p. 63, RX 20769/956.

The following illustrations have been reproduced courtesy of The Newberry Library, Chicago: pp. 12, 14, 24, 29, 44, 61.